Apples 🍎🍎 for Teachers

A Basic Skills Reinforcement Program for Young Children

Colors and Shapes

by
Diane Burkle
Cynthia Polk Muller
and
Linda J. Petuch

Fearon Teacher Aids
Belmont, California 94002

Simon & Schuster Supplementary Education Group

Illustrator: Pauline Phung
Cover illustration by: Marilynn G. Barr

ISBN 0-8224-0459-1

Printed in the United States of America

1. 9 8 7 6 5 4

contents

introduction

Colors and Shapes is designed to enhance primary education through the use of manipulatives and tactile materials. The learning activities help students develop visual, auditory, kinesthetic, tactile, and perceptual skills while providing opportunities for creative expression. Although students may appear to be participating in art projects, they are, in fact, achieving artistically such curriculum objectives as recognizing color words and shape words, distinguishing between colors and shapes, and developing eye-hand coordination and fine motor skills.

The worksheets contained here are structured to allow repetition when learning new concepts—an approach that educators have noted is essential for internalizing concepts and skills. The learning materials are specifically designed to appeal to young children and to provide them with the positive reinforcement they need for learning new skills.

Worksheet-based activities require minimal teacher preparation and can be used with students working individually, in small groups, or in independent learning centers. Most of these activities use common school supplies such as crayons, scissors, and glue or paste. Some activities require additional materials that are inexpensive and readily available in many classrooms or from art supply stores.

To administer an activity, assemble and distribute the necessary materials. (Materials lists, along with suggestions for variations, extensions, and enrichment activities, are provided in the section called "Using the Worksheets.") Read the worksheet instructions aloud to the students and make sure they understand what to do. Provide help as needed (especially with the use of a hole punch), and always supervise the use of scissors and glue.

We hope you enjoy using this book and, most of all, that it makes learning fun for your students.

using the worksheets

There are four worksheets for each of eight colors and five worksheets for each of six shapes. Review worksheets, which reinforce color and shape discrimination, are also included. After your students have completed one or two worksheets of a kind, they may be able to complete the others of that kind without instructions. Use the following notes to help you administer each kind of worksheet:

learning colors

(pp. 15, 19, 23, 27, 31, 35, 39, and 43)

objectives and skills

Recognizing colors
Associating colors with color words
Developing eye-hand coordination

materials

crayons

variations

✓ Have each student trace the color word with the index finger.

✓ You may wish to have the children do a crayon-resist activity (painting over the crayoned words) instead of just coloring the words. If so, encourage them to press hard while coloring, and to fill in all areas of the outlined letters. As they paint, encourage them to make their strokes in a left-to-right direction.

✓ Instead of having students color the letter outlines, have them glue torn pieces of construction paper inside the letters.

extensions

✓ Have students cut out the letters and arrange them in order to spell the color word.

✓ Create a bulletin board display of cutout words, allowing students to arrange them in the order learned.

✓ Provide writing paper for students to practice writing the color words.

✓ Have students find pictures of objects in a given color and circle them in crayon.

✓ Name objects in a given color and encourage students to name other objects in that color.

✓ Initiate a guessing game in which one student thinks of an object with the given color and the rest of the class asks questions about the object to identify it. (You may wish to limit the game to objects in the classroom, or use a theme such as fruits and vegetables, flowers, or animals.)

drawing in colors (pp. 16, 20, 24, 28, 32, 36, 40, and 44)

objectives and skills
Differentiating colors
Identifying colors by their color words
Developing eye-hand coordination
Developing fine motor skills

materials
crayons or colored pencils

variations
✓ Have students create same-color mosaics by gluing scraps of construction paper on the shape.

✓ Discuss what the shape on each page is and why it represents that color.

extensions
✓ Suggest that students decorate their shape by tracing its outline in glue and sprinkling glitter or sand over it.

✓ Have students cut out the shape and use it as a pattern for tracing on construction paper in that color. Students can then cut out the shapes and work in cooperative groups to create a montage, which can be displayed in the classroom.

enrichment
✓ Ask students to name an object in the given color and to draw a picture of that object on a sheet of plain paper or on the back of their worksheets.

picturing colors

objectives and skills Discriminating colors of objects
Developing fine motor skills

materials crayons

extensions ✓ Have students roughly cut out the objects they colored and work together to create pictures with numerous objects. The cutouts can be glued onto butcher paper or tagboard and posted on the bulletin board.

✓ Have students save each uncolored object for later lessons, or color it using an appropriate color.

enrichment ✓ Ask students to describe each colored object on the worksheet and tell a story about why that object is a given color. Encourage them to use their imagination. You may also ask them to explain why they did not color a certain object on the worksheet. Discuss objects that could be other colors.

✓ Encourage students to name other objects in the given color and to draw them on plain paper or on the back of the worksheet.

fun with colors

objectives and skills Reinforcing color recognition
Developing creativity
Developing fine motor skills
Developing direction-following skills, using pictorial and auditory directions

variations ✓ Most worksheet pictures can be decorated using a variety of materials in addition to those suggested below. Optional materials may include dry macaroni, birdseed, confetti, paper "holes" from a hole punch, fabric scraps, torn or cut construction paper, wallpaper scraps, sequins, buttons, felt, colored tape, and adhesive stickers such as stars and dots.

✓ It is a good idea to have the children use glue sticks instead of glue or paste. Glue sticks are available at most stationery stores or art supply stores, they are convenient, and they keep artwork (and children's hands!) neat and clean.

extension ✓ Display the finished artwork on a bulletin board or on a table or shelf in your classroom.

materials (per student)

Fun with Red *(p. 18)*
red crayons
red tissue paper cut into
 2-inch squares
glue

Fun with Blue *(p. 22)*
blue crayons
glue
tiny fabric scraps
glitter

Fun with Yellow *(p. 26)*
yellow crayons
glue
eight 2-inch lengths of
 yellow yarn

Fun with Green *(p. 30)*
green crayons
two 8-inch strips of green
 construction paper
scissors
glue

Fun with Orange *(p. 34)*
glue
orange crayons
12 ½-inch lengths of
 orange yarn

Fun with Purple *(p. 38)*
purple crayons
hole punch
purple construction paper
glue

Fun with Brown *(p. 42)*
brown crayons
six cotton balls
glue

Fun with Black *(p. 46)*
black crayons
six black pipe cleaners
glue

making color books

(pp. 47–50)

objectives and skills

Recognizing and writing color words
Developing fine motor skills

materials and directions	crayons
	construction paper
	stapler

After students have colored the pictures and traced the words on each page, show them how to fold the pages in half to make a booklet. Give the students construction paper for the covers. Have them fold this paper in half. Students should decorate the covers and write their names on them. Staple the booklets for the students.

reviewing colors (pp. 51–58)

objectives and skills Differentiating colors
Developing fine motor skills
Developing direction-following skills, using pictorial and auditory directions

materials crayons

extensions ✓ Have students glue yarn around the perimeter of their completed pictures as a "frame."

✓ Provide a variety of materials for students to decorate their pictures. For ideas, use the list in variations for "Fun with Colors" or the suggestions for optional materials following.

enrichment ✓ Have students draw their own pictures, using objects that are identified by certain colors.

✓ Have students work in groups to create their own pictures, with each student using only one color.

✓ Ask each student to create a story to accompany the picture. Dictate the stories on the students' papers or on another sheet of paper. Display the pictures and stories on the bulletin board.

learning shapes

(pp. 59, 65, 70, 75, 81, and 86)

objectives and skills

Recognizing basic shapes
Drawing basic shapes
Developing eye-hand coordination
Developing fine motor skills
Developing direction-following skills, using pictorial and
auditory directions

materials

crayons
glue
glitter or sand
yarn in 12-inch lengths

variations

✓ Have students create mosaics by gluing scraps of colored con-
struction paper inside one of the shapes.

✓ The worksheets can be decorated using a variety of materials.
See the variations for "Fun with Colors."

extensions

✓ Have students cut out the shapes and glue them on a contrast-
ing background such as colored construction paper.

✓ Have students cut out their shapes and use them as patterns for
tracing.

✓ After students have completed all worksheets of this kind, create
a bulletin board display of cutout shapes, allowing students to
sort them by shape.

enrichment	✓ Introduce the word for each shape and have students repeat the word aloud.

✓ Name objects that have the given shape and encourage students to name other objects having that shape.

✓ Initiate a guessing game in which one student thinks of an object having a given shape and the rest of the class asks questions about the object to identify it. Since it may be difficult to limit students to basic shapes, you may wish to have them extend the basic shape names to three-dimensional objects. For example, a globe might be considered a circle. You might also have them consider parts of objects, such as an animal's eye (a circle).

lacing shapes (pp. 60, 66, 71, 76, 82, and 87)

objectives and skills
Recognizing basic shapes
Developing eye-hand coordination
Developing fine motor skills

materials
crayons
scissors
glue or paste
8½ inch × 11 inch tagboard
hole punch
yarn in 36-inch lengths

variations
✓ Allow students to lace the shape in a variety of ways, including over and under—lacing around the outside of the shape (in a whipstitch—or in and out—lacing down through one hole and up through the next. The first method is generally easier for students.

✓ Prepare the lacing cards for students to use on their own: laminate a trimmed copy of the worksheets onto tagboard, and punch out the holes. This way, students will only have to perform the lacing part of the activity.

enrichment
✓ Provide yarn in longer lengths and have students practice tying knots and bows.

matching shapes (pp. 61–62, 67, 72, 77–78, 83, and 88–89)

objectives and skills Comparing shapes of various sizes
Developing fine motor skills

materials crayons
scissors
glue

extensions ✓Have students search through old newspapers and magazines for pictures that contain a given shape. They may circle the pictures or cut them out and glue them to a sheet of plain paper.

✓Have students cut out the picture they assembled on the worksheet and work in cooperative groups to create a montage.

cutting shapes (pp. 63, 68, 73, 79, 84, and 90)

objectives and skills Reinforcing basic shapes
Developing fine motor skills

materials crayons
scissors

extensions ✓Create hanging mobiles by having students punch a hole in the center of the cutout shape and thread a knotted piece of yarn through the hole.

✓Have students work in small groups to create multiple-shape mobiles. Provide each group with a sheet of cardboard, precut in the given shape and with one hole already punched for each group member. Have them thread the yarn of their individual mobiles through the holes in the cardboard and tie the ends of all yarn pieces together. Hang the mobiles in the classroom.

building with shapes (pp. 64, 69, 74, 80, 85, and 91)

objectives and skills	Reinforcing basic shapes Comparing shapes of various sizes Developing direction-following skills, using pictorial and auditory directions
materials	crayons scissors 8½ inch × 11 inch construction paper
extension	✓ Display the finished artwork on a bulletin board or on a table or shelf in the classroom.
enrichment	✓ Have students draw the given shape on a plain piece of paper and then add shapes to it to create their own pictures.

reviewing shapes (pp. 92–96)

objectives and skills	Distinguishing basic shapes Developing fine motor skills Developing direction-following skills, using pictorial and auditory directions
materials	crayons scissors glue
extension	✓ Provide writing paper for capable students to practice writing the words for the different shapes they have learned.
enrichment	✓ Have each student trace a hand on paper, color it, and cut it out. Allow the students to work in small groups to create a montage with their cutout hand shapes, adding other drawn or cutout shapes to the montage if they wish. ✓ Have students trace different objects on paper, such as scissors, pencils, erasers, plastic containers, and other classroom objects. Ask them to identify the different shapes.

setting up learning centers

The worksheet-based activities in this book may be adapted to a learning center environment. Most worksheets focus on a separate color or shape, and the worksheets are usually repeated (sometimes with slight variation) for every color or shape. Hence, even young children who cannot yet read may be able to work at a learning center, without teacher direction, completing worksheets on their own or in small groups. Here are some suggestions that may help you in setting up learning centers in your classroom:

1 Set up a separate learning center for each subject area. Identify the center by hanging a symbol, such as a building block of a certain color or a paper shape, over the table set up for that learning center.

2 Gather materials that students will need for the activity. Place those materials in boxes or other appropriate containers, and label the containers with the word and a picture of the item contained. Store these containers in the learning center.

3 For activities requiring paint, glue, or paste, tape a protective covering over the learning center table. Keep the covering on the table as long as that learning center continues to be used.

4 Prepare samples of the activities. Post the samples on the bulletin board or in the learning center so students can refer to them.

5 Explain each activity before the students begin working on their own. You may need to review the directions on a daily basis.

6 If you have a few learning centers set up, students may work at the centers in rotation. Group students by ability, by compatibility, or in some random fashion. Create a chart that shows who is in each group, and post the chart on a bulletin board. Create tags that match the learning center symbols (see suggestion 1), and pin a different tag next to each group listed on the chart. The tag will tell the group which center they should go to that day. Change the tags each day.

Some activities are especially appropriate for cooperative learning situations. You may wish to assign roles, such as gathering materials, cleaning up after the activity, collecting the worksheets and making sure group members have written their names on their papers, and so on. You might also want to provide an appropriate social goal such as working quietly, asking group members for help, and so on.

7 Provide adequate space for the completed worksheets to dry if they have just been glued, pasted, or painted. Try not to stack or overlap the worksheets while they dry.

14

Name _____

Use **red** to color the letters.

Name _____

Color the heart **red**.
Draw some more hearts. Color them **red**.

red

Colors and Shapes © 1988

Name _____

Color **red** the things that can be **red**.

Name _____

Color the rose **red**.
Make tissue balls by rolling pieces of red tissue paper between your hands.
Put glue on the rose. Glue the tissue balls on the rose.

red rose

Name _____

Use blue to color the letters.

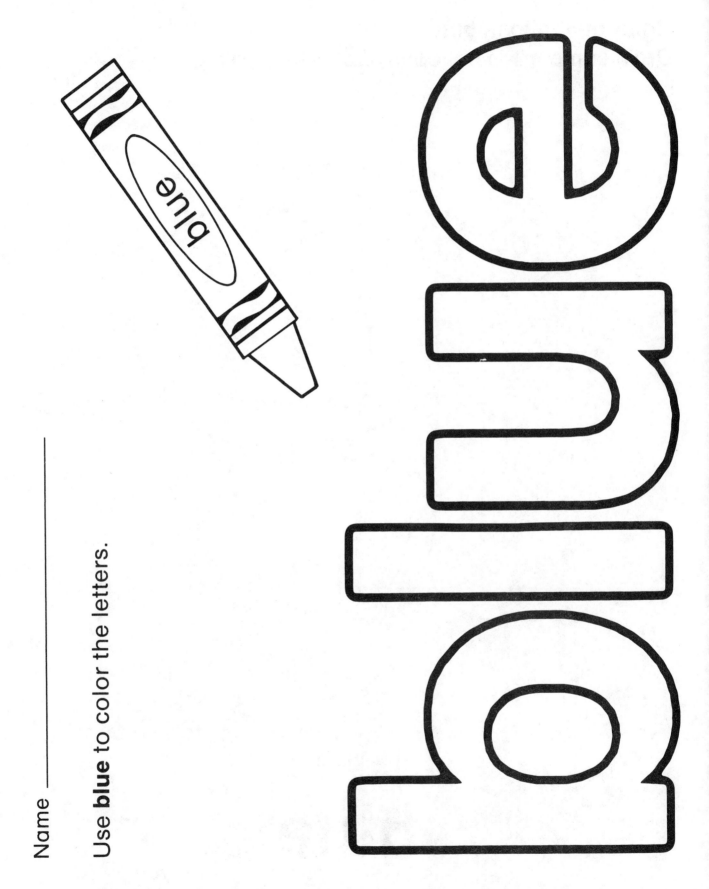

Name _____

Color the balloon **blue**.
Draw some more balloons. Color them **blue**.

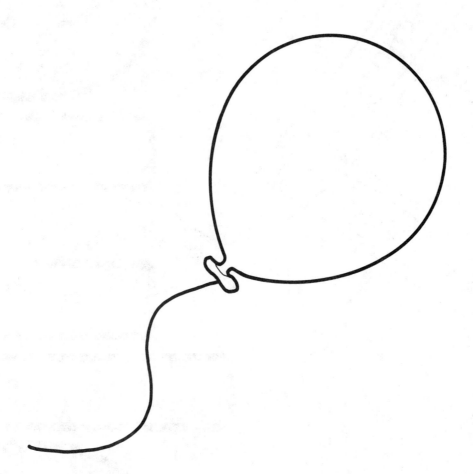

blue

Colors and Shapes © 1988

Name _____

Color **blue** the things that can be **blue**.

Name _____

Color the jeans **blue**.
Glue fabric scraps on for patches. Glue glitter on the belt.

blue jeans

Name _____

Use **yellow** to color the letters.

yellow

Name _____

Color the banana **yellow**.
Draw some more bananas. Color them **yellow**.

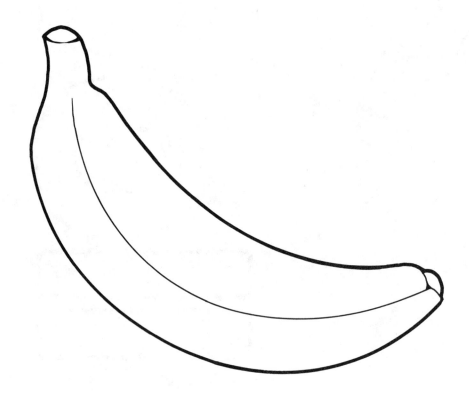

yellow

Name _____

Color **yellow** the things that can be **yellow**.

Name _____

Color the sun **yellow**.
Glue **yellow** yarn around the sun.

yellow sun

Colors and Shapes © 1988

Name _____

Use green to color the letters.

green

Name _____

Color the tree **green**.
Draw some more trees. Color them **green**.

green

Colors and Shapes © 1988

Name _____

Color **green** the things that can be **green**.

Name _____

Color the trees **green**.
Cut strips of **green** paper. Glue them below the trees.

green trees and grass

Name _____

Use **orange** to color the letters.

Name _____

Color the pumpkin **orange**.
Draw some more pumpkins. Color them **orange**.

orange

Colors and Shapes © 1988

Name _____

Color **orange** the things that can be **orange**.

Name _____

Color the caterpillar **orange**.
Glue **orange** yarn on the caterpillar.

orange caterpillar

Name _____

Use **purple** to color the letters.

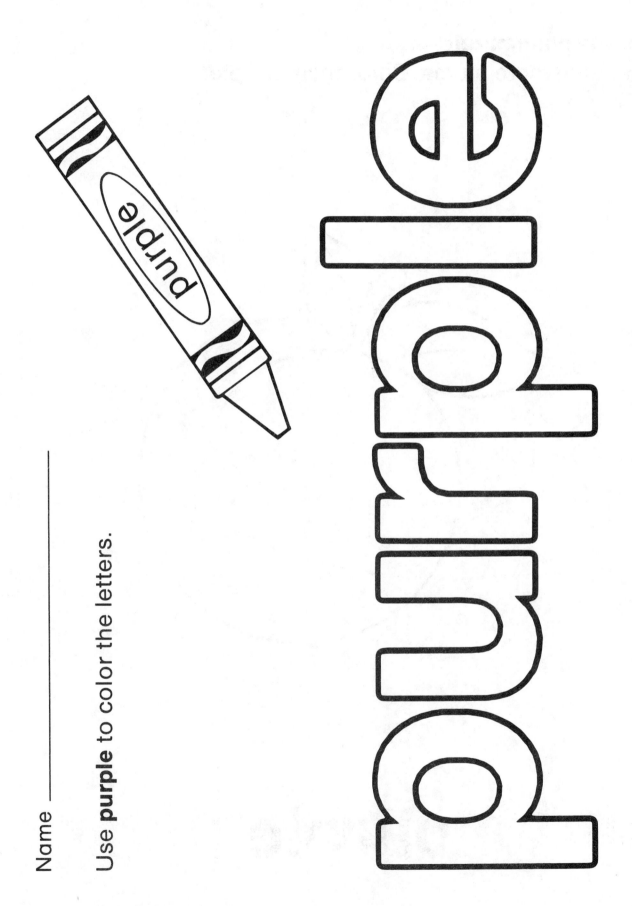

Name _____

Color the plum **purple**.
Draw some more plums. Color them **purple**.

purple

Colors and Shapes © 1988

Name _____

Color **purple** the things that can be **purple**.

Name _____

Color one bunch of grapes **purple**.
Punch out circles from **purple** paper.
Glue the circles on the other bunch of grapes.

purple grapes

Name _____

Use **brown** to color the letters.

brown

Colors and Shapes © 1988

Name _____

Color the log **brown**.
Draw some more logs. Color them **brown**.

brown

Colors and Shapes © 1988

Name _____

Color **brown** the things that can be **brown**.

Name _____

Color the bear **brown**.
Glue cotton balls on the bear's ears and feet.

brown bear

Name _____

Use **black** to color the letters.

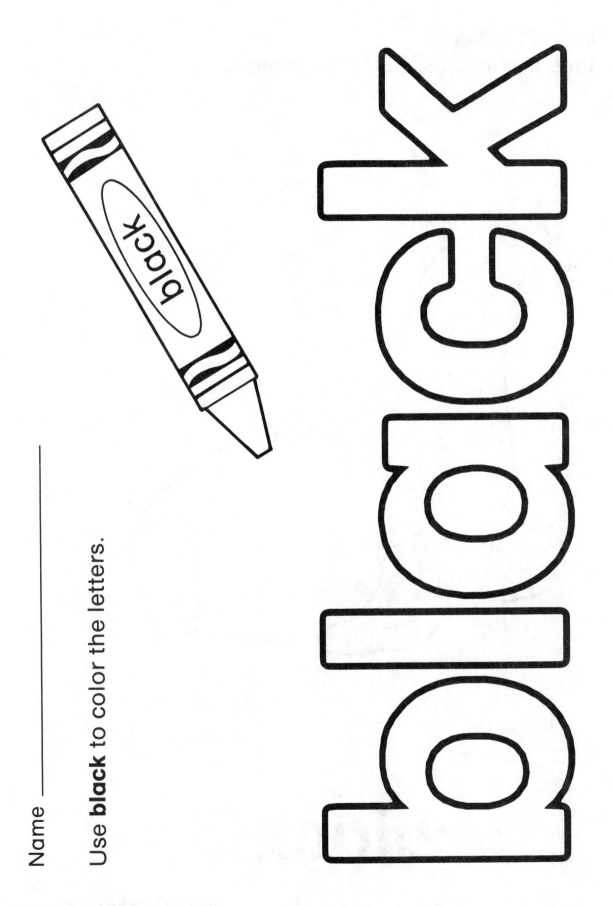

Name _____

Color the seal **black**.
Draw some more seals. Color them **black**.

black

Colors and Shapes © 1988

Name _____

Color **black** the things that can be **black**.

Name _____

Color the beetle **black**.
Glue on pipe cleaners for legs.

black beetle

Name _____

Color the pictures. Trace the words.

blue

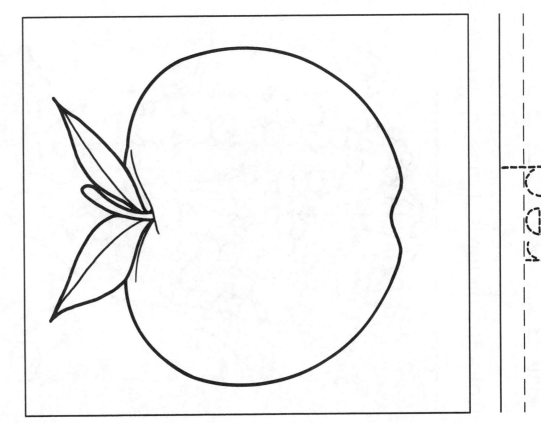

red

green

Name _____

Color the pictures. Trace the words.

yellow

Colors and Shapes © 1988

purple

orange

Name _____

Color the pictures. Trace the words.

Name _____

Color the pictures. Trace the words.

black

brown

Name _____

Use **red** and **blue** to color the picture.

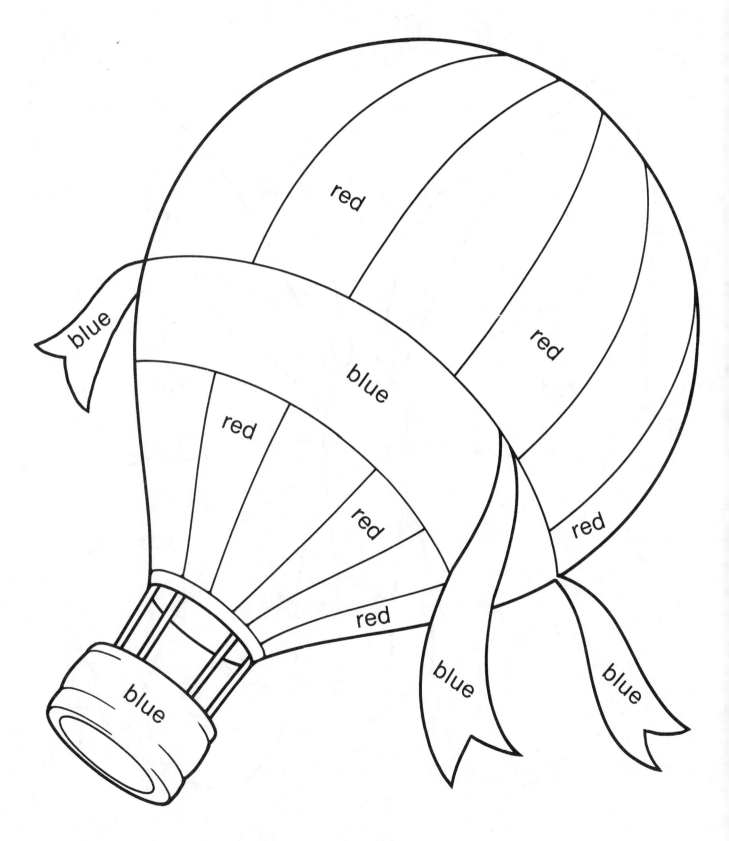

Name _____

Use **red, blue,** and **yellow** to color the picture.

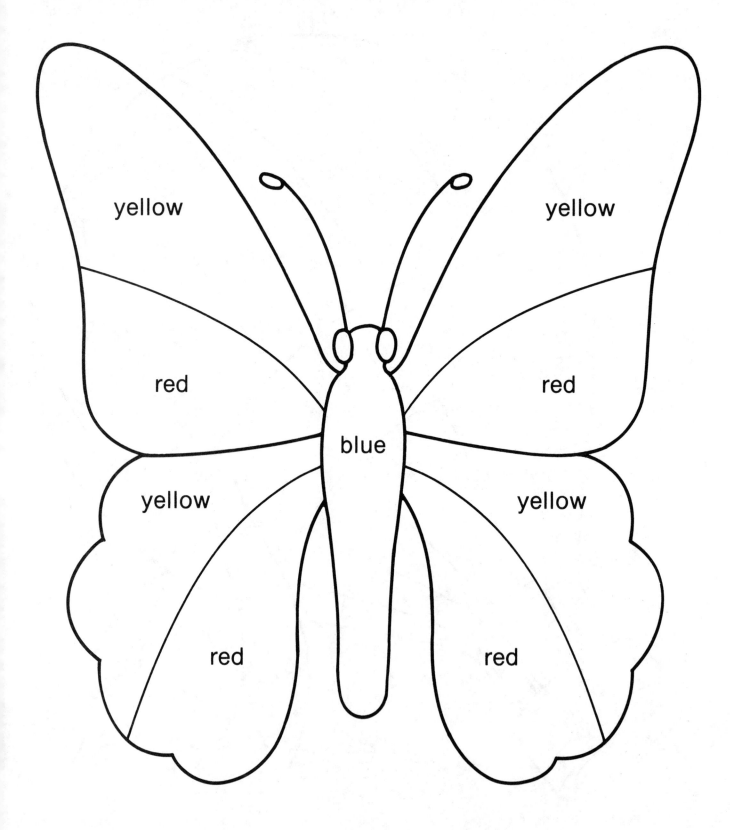

Name _____

Use **red, blue, yellow,** and **green** to color the picture.

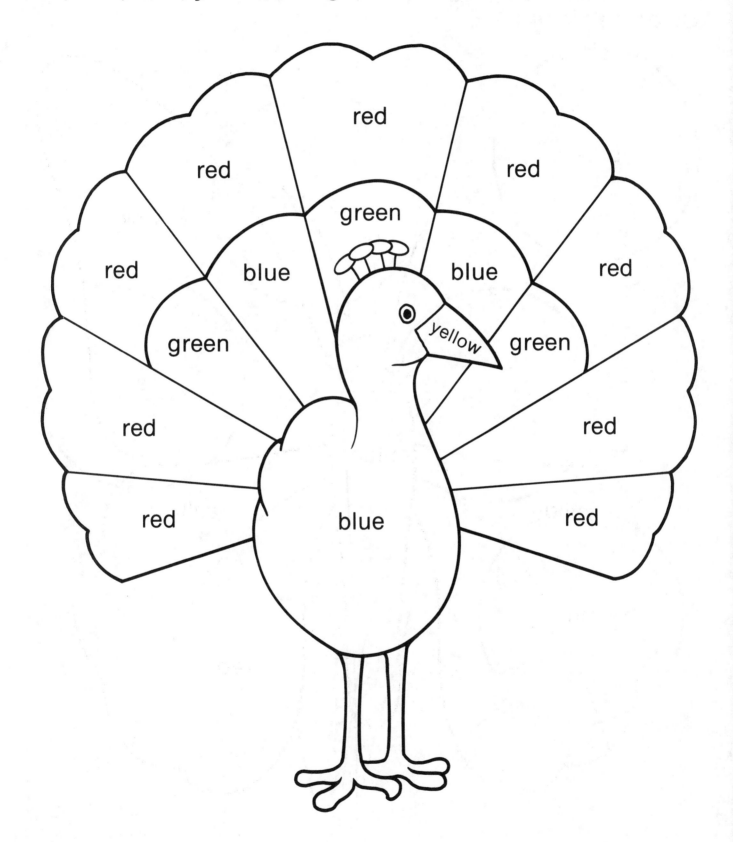

Name _____

Use **red, blue, yellow, green,** and **orange**.
Color the picture.

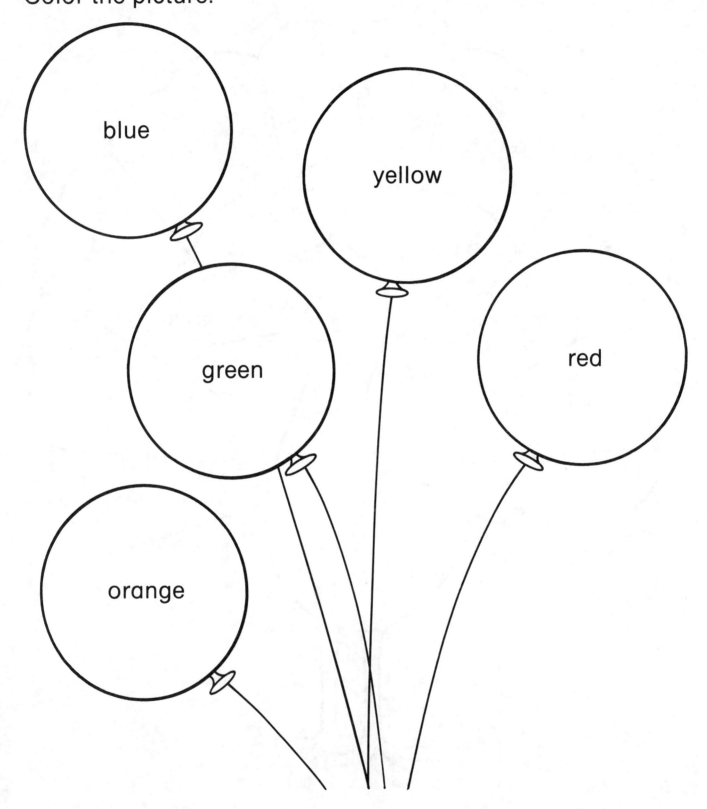

Name _____

Use **red, blue, yellow, green, orange,** and **purple**.
Color the picture.

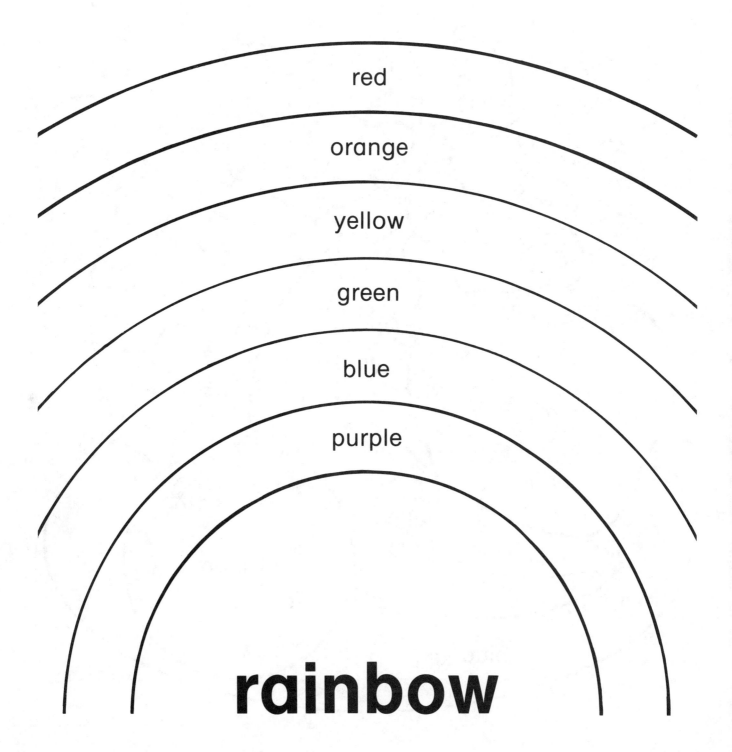

red

orange

yellow

green

blue

purple

rainbow

Name _____

Use **red, blue, yellow, green, orange, purple,** and **brown**.
Color the picture.

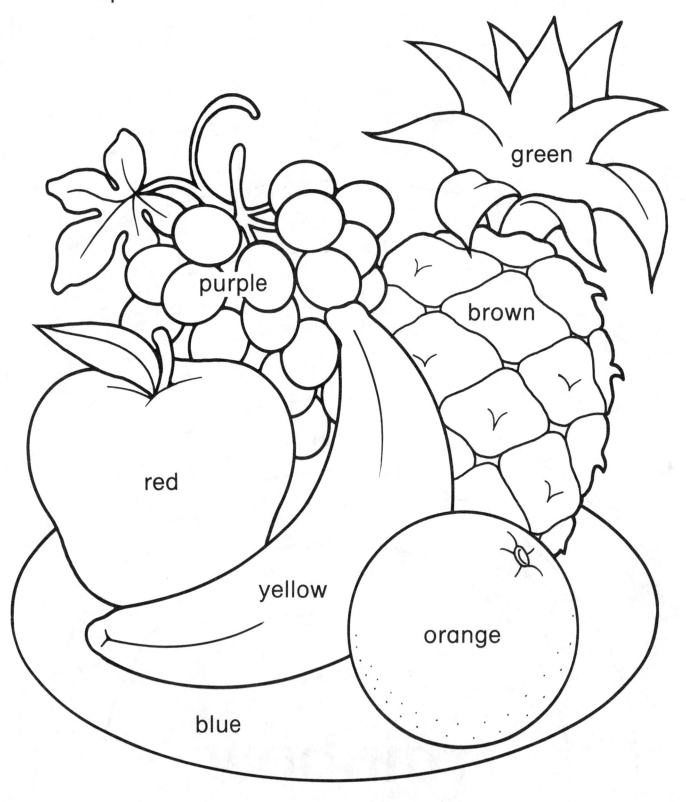

Colors and Shapes © 1988

Name _____

Use **red, blue, yellow, green, orange, purple, brown,** and **black**. Color the picture.

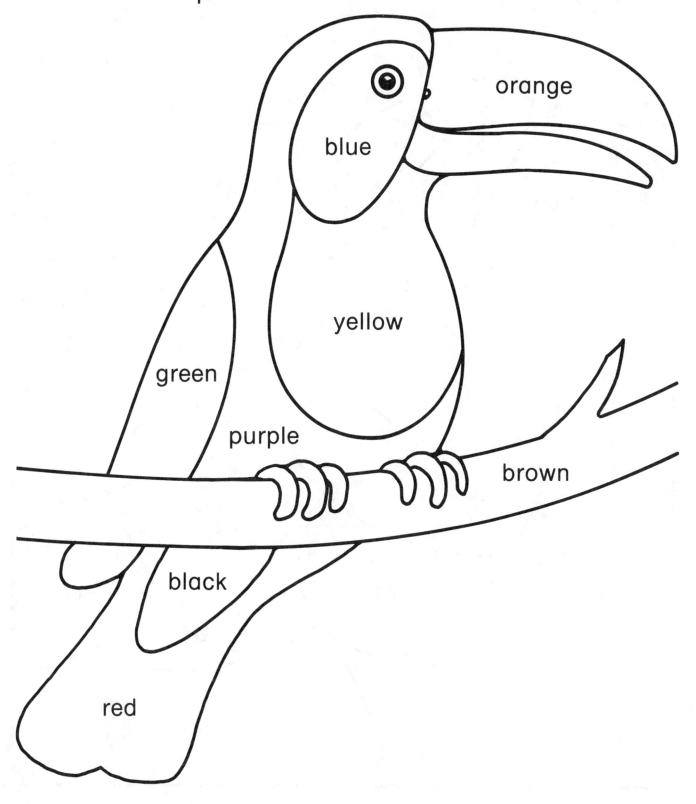

Name _____

Color each shape the correct color.
Find the picture.

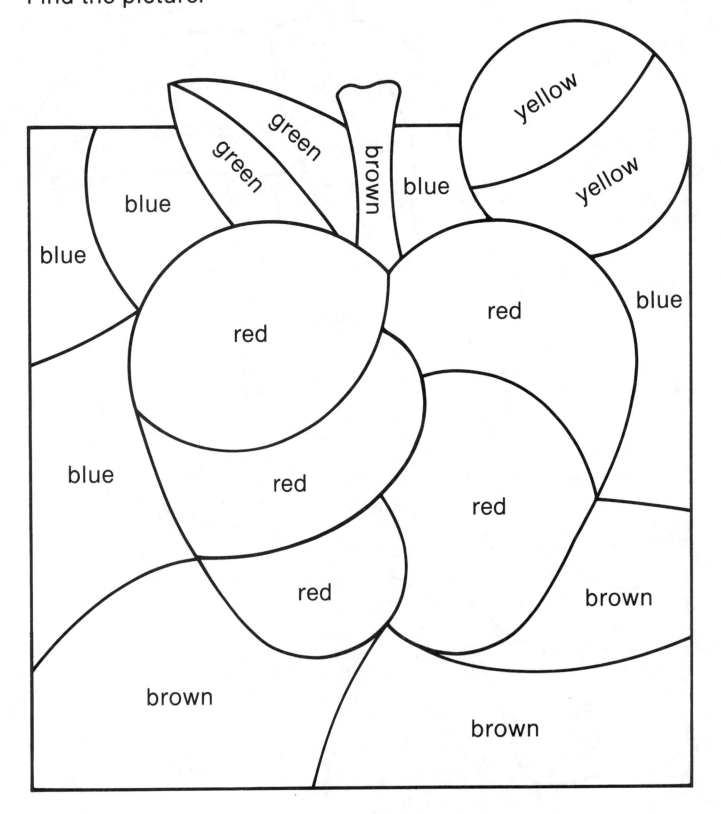

Name _____

Color the inside of the circle.

Trace the circle with glue. Then sprinkle with glitter or sand.

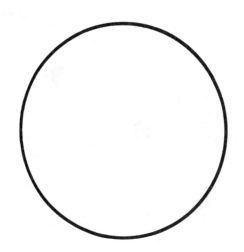

Color the outline of the circle.

Draw smaller and smaller circles inside it.

Glue yarn around the biggest circle.

Draw your own circle and color it.

circle

Name _____

Color the circle and glue this page on tagboard.
Cut out the circle. Punch out the black dots.
Lace yarn through the holes and tie the ends.

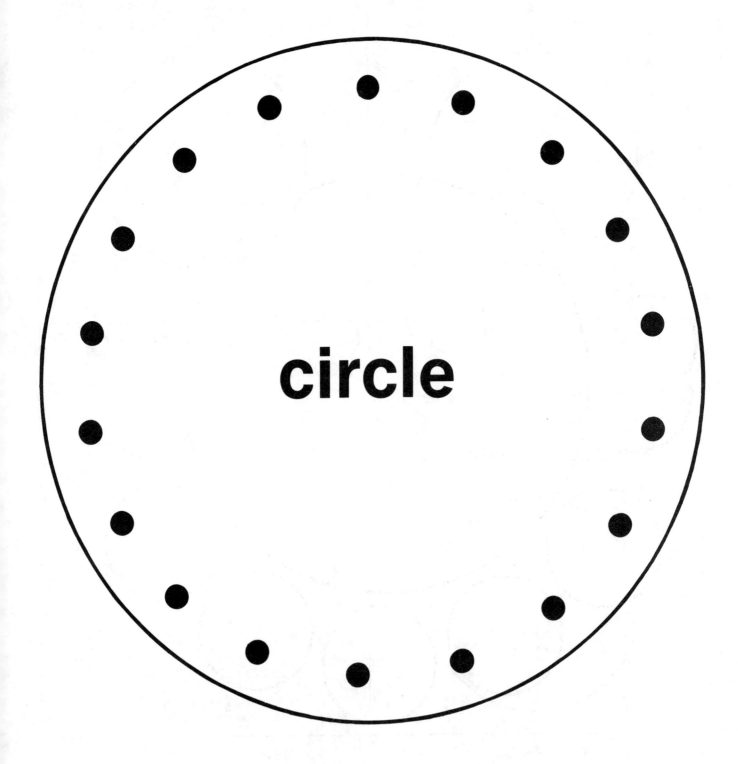

circle

Name _____

Color the shapes. Then cut them out.
Glue the shapes on the clown where they belong.

62

Name _____

Start at the dot. Follow the broken line with a crayon.
Color the rest of the shape. Cut along the broken line.

Name _____

Color the shapes below. Then cut them out.
Glue them on another piece of paper
to make this bear.
Draw the bear's eyes and mouth.

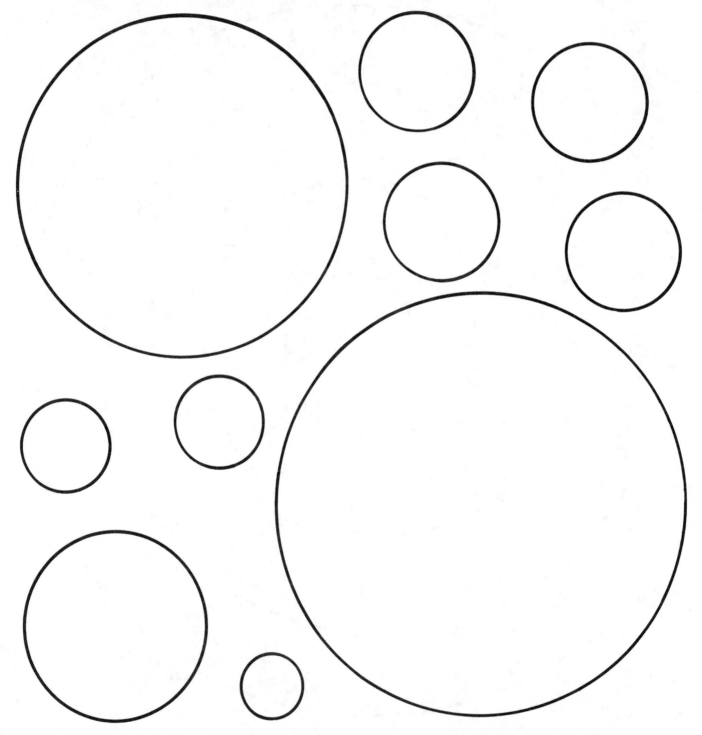

Name _____

Color the inside of the
 square.

Trace the square with glue.
Then sprinkle with glitter or
 sand.

Color the outline of the
 square.
Draw smaller and smaller
 squares inside it.
Glue yarn around the biggest
 square.

Draw your own square and
 color it.

square

Name _____

Color the square and glue this page on tagboard.
Cut out the square. Punch out the black dots.
Lace yarn through the holes and tie the ends.

square

Colors and Shapes © 1988

Name _____

Color the squares below the broken line. Then cut them out. Glue the shapes in place on the buildings below.

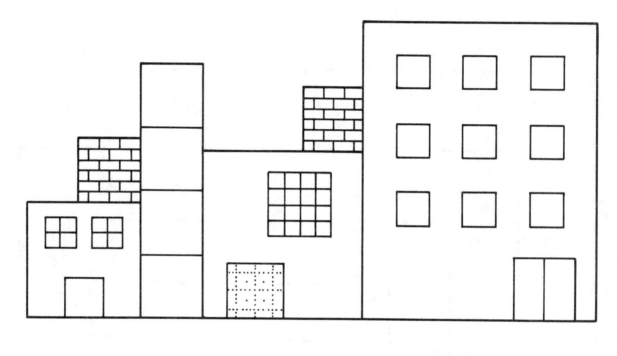

- -

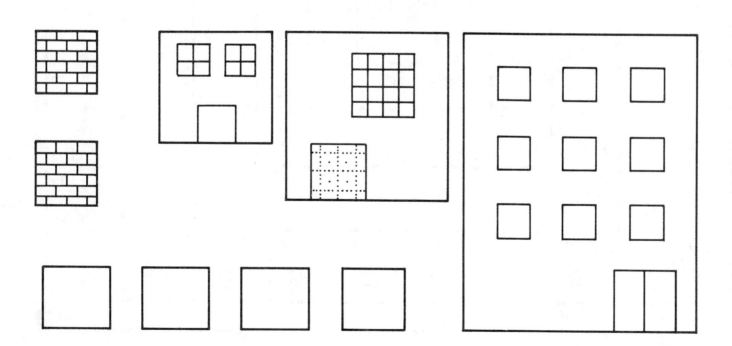

Name _____

Start at the dot. Follow the broken line with a crayon.
Color the rest of the shape. Cut along the broken line.

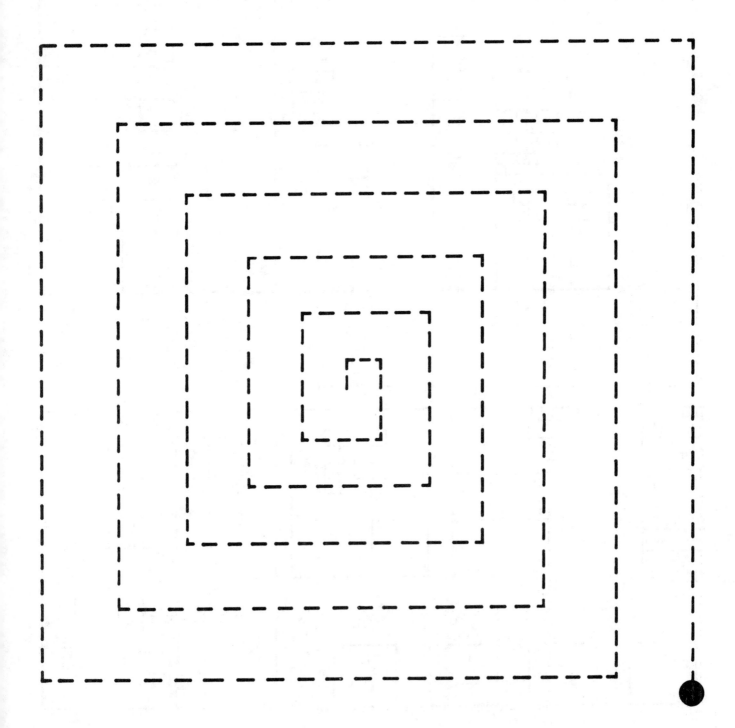

Colors and Shapes © 1988

Name _____

Color the shapes below. Then cut them out.
Glue them on another piece of paper to make this truck.

apples

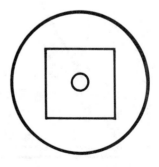

Name _____

Color the inside of the triangle.

Trace the triangle with glue. Then sprinkle with glitter or sand.

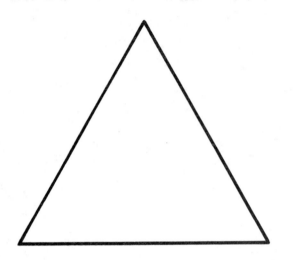

Color the outline of the triangle.
Draw smaller and smaller triangles inside it.
Glue yarn around the biggest triangle.

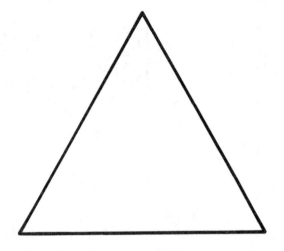

Draw your own triangle and color it.

triangle

Name _____

Color the triangle and glue this page on tagboard.
Cut out the triangle. Punch out the black dots.
Lace yarn through the holes and tie the ends.

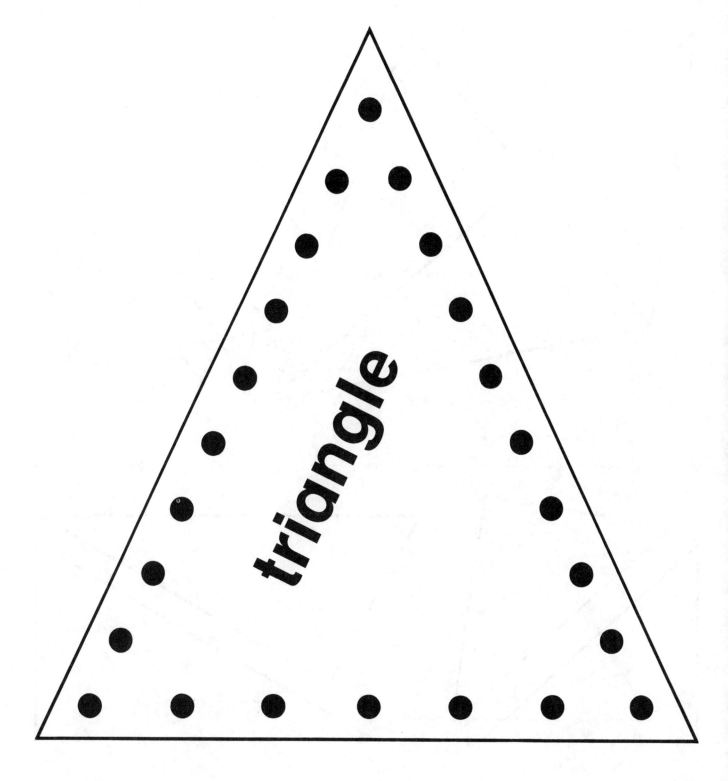

Name _____

Color the triangles below the broken line. Then cut them out. Glue the shapes in place on the kite below.

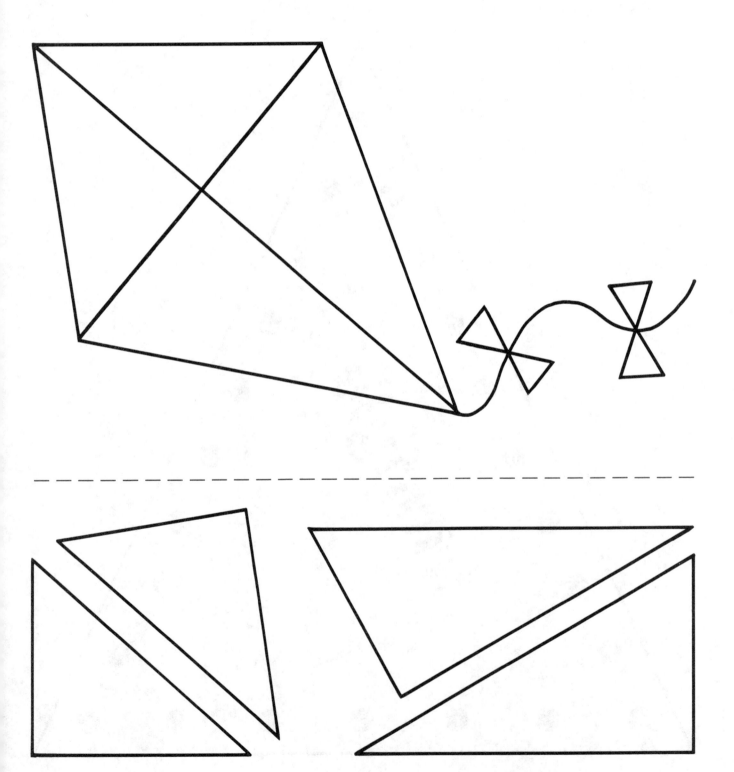

Colors and Shapes © 1988

Name _____

Start at the dot. Follow the broken line with a crayon.
Color the rest of the shape. Cut along the broken line.

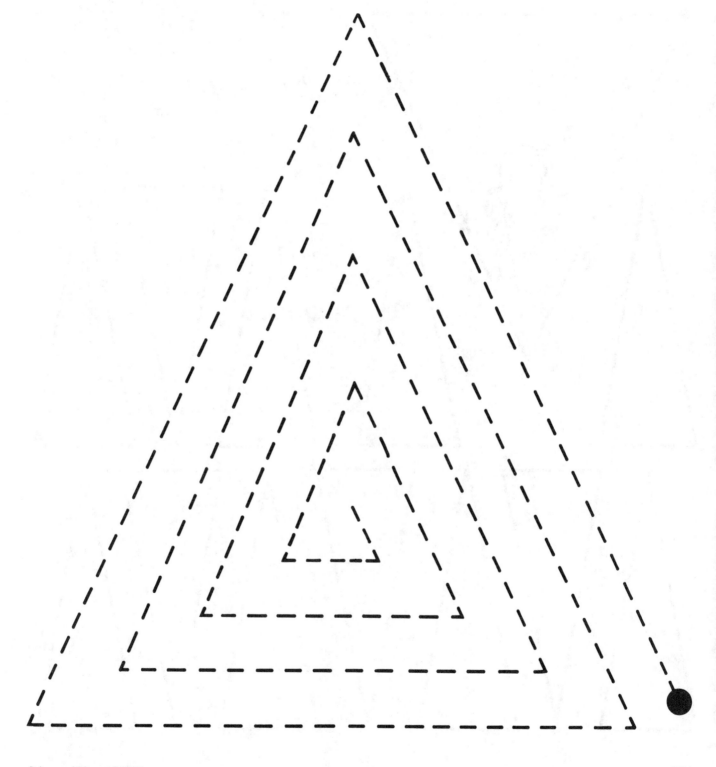

Name _____

Color the triangles below and cut them out. Glue them on
another piece of paper to make this turkey.
Draw legs on the turkey.

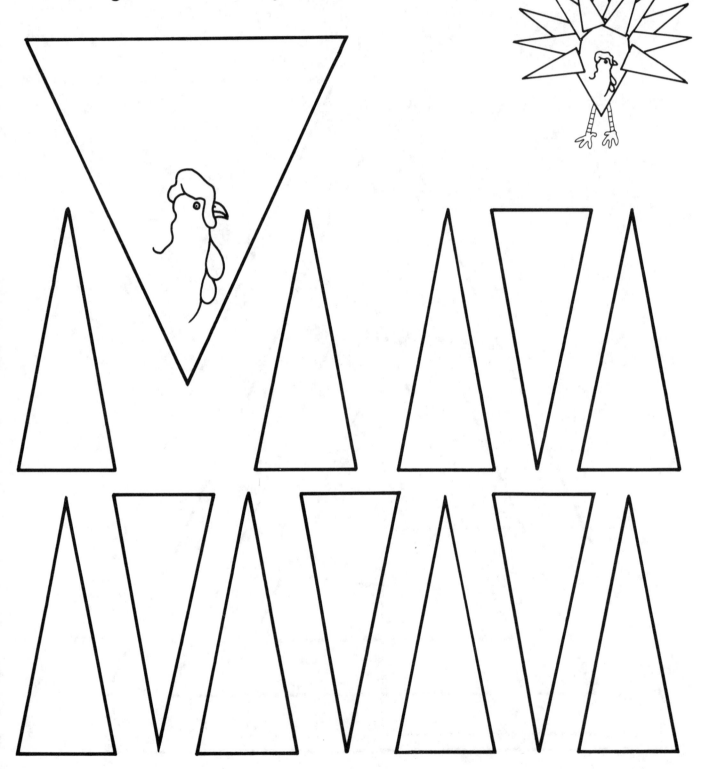

Colors and Shapes © 1988

Name _____

Color the inside of the
 rectangle.

Trace the rectangle with glue.
Then sprinkle with glitter or
 sand.

Color the outline of the
 rectangle.
Draw smaller and smaller
 rectangles inside it.
Glue yarn around the
 biggest rectangle.

Draw your own rectangle and
 color it.

rectangle

Name _____

Color the rectangle and glue this page on tagboard.
Cut out the rectangle. Punch out the black dots.
Lace yarn through the holes and tie the ends.

rectangle

Name _____

Color the wagon shapes. Then cut them out.
Glue the shapes in place on the wagon below.

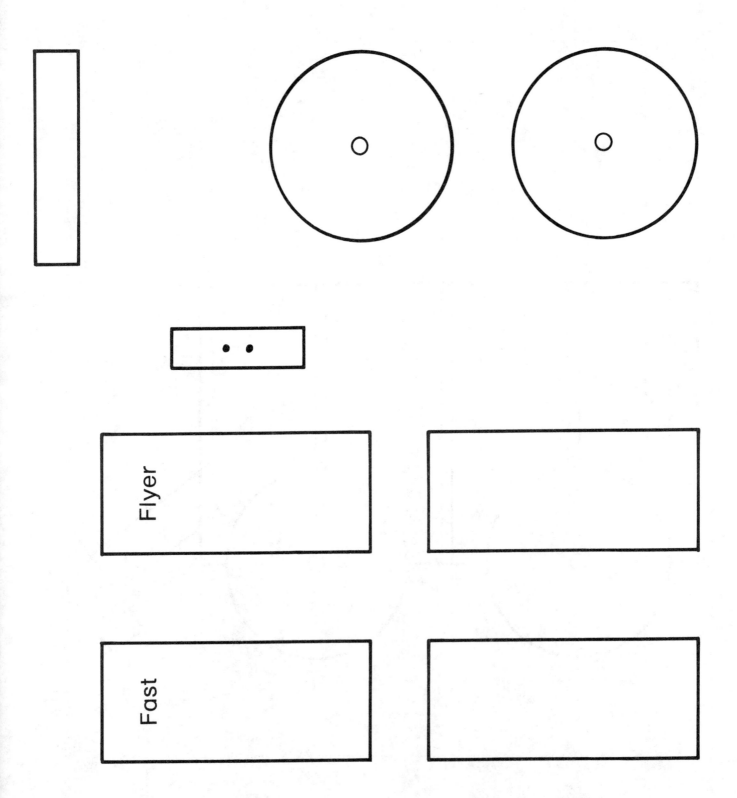

Flyer

Fast

Colors and Shapes © 1988

Name _____

Start at the dot. Follow the broken line with a crayon.
Color the rest of the shape. Cut along the broken line.

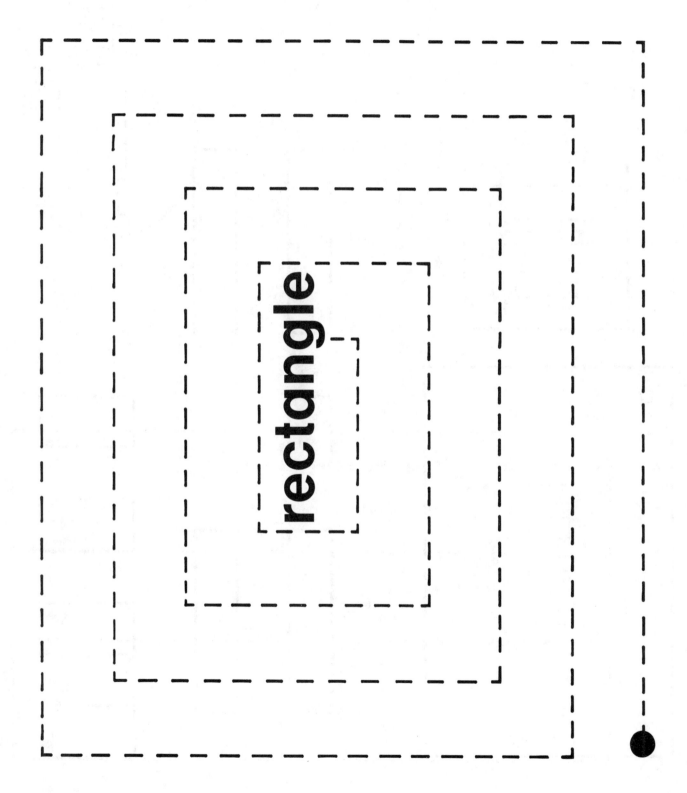

rectangle

Name _____

Color the shapes below and cut them out.
Glue them on another piece of paper to make this robot.

Colors and Shapes © 1988

Name _____

Color the inside of the diamond.	Trace the diamond with glue. Then sprinkle with glitter or sand.

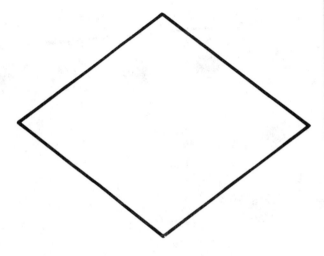

Color the outline of the diamond.
Draw smaller and smaller diamonds inside it.
Glue yarn around the biggest diamond.

Draw your own diamond and color it.

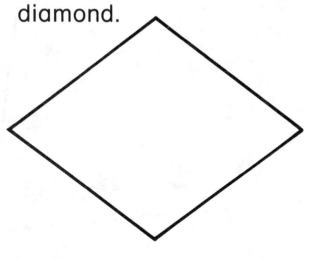

diamond

Name _____

Color the diamond and glue this page on tagboard.
Cut out the diamond. Punch out the black dots.
Lace yarn through the holes and tie the ends.

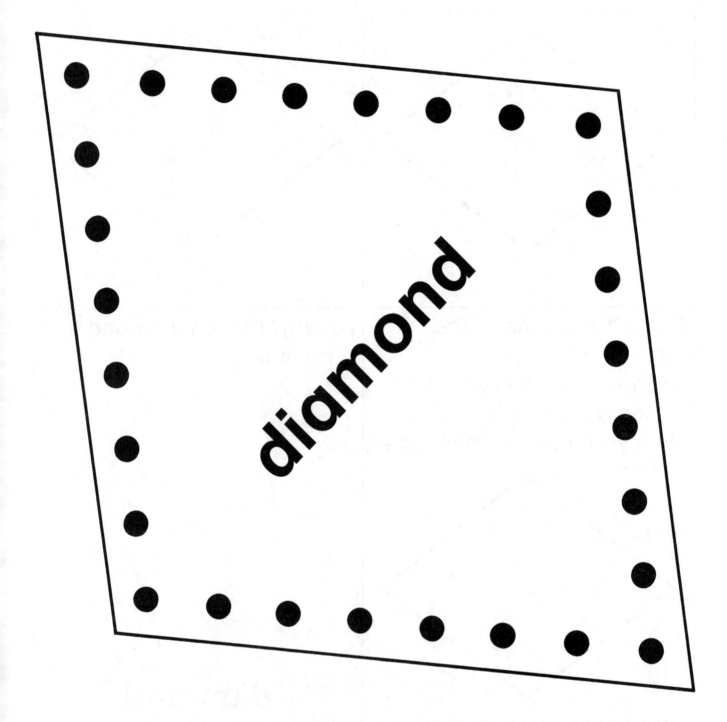

Name _____

Color the diamonds to the right of the broken line.
Then cut them out.
Glue the diamonds in place on the card below.

Name _____

Start at the dot. Follow the broken line with a crayon.
Color the rest of the shape. Cut along the broken line.

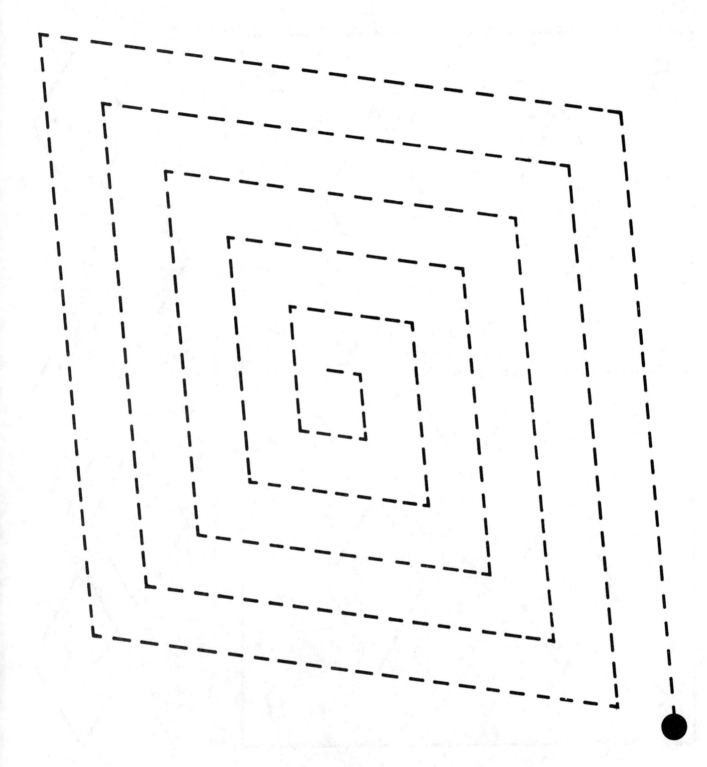

Name _____

Color the diamonds below and cut them out.
Glue them on another piece of paper to make
this design.

Name _____

Color the inside of the oval.

Trace the oval with glue.
Then sprinkle with glitter or
sand.

Color the outline of the oval.
Draw smaller and smaller
ovals inside it.
Glue yarn around the
biggest oval.

Draw your own oval and
color it.

oval

Name _____

Color the oval and glue this page on tagboard.
Cut out the oval. Punch out the black dots.
Lace yarn through the holes and tie the ends.

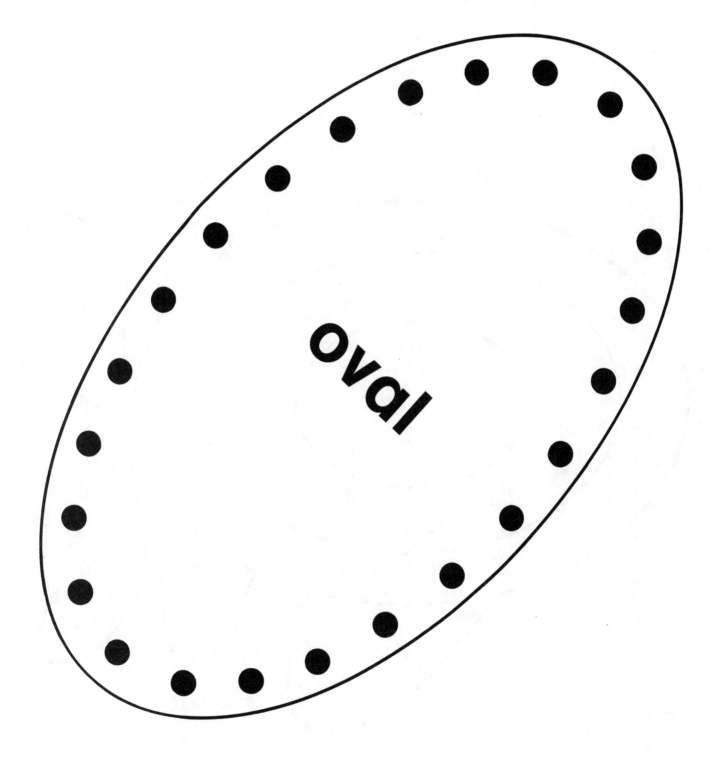

oval

Name _____

Color the oval shapes. Then cut them out.
Glue ovals in place on the fish below.
Glue the largest oval first.

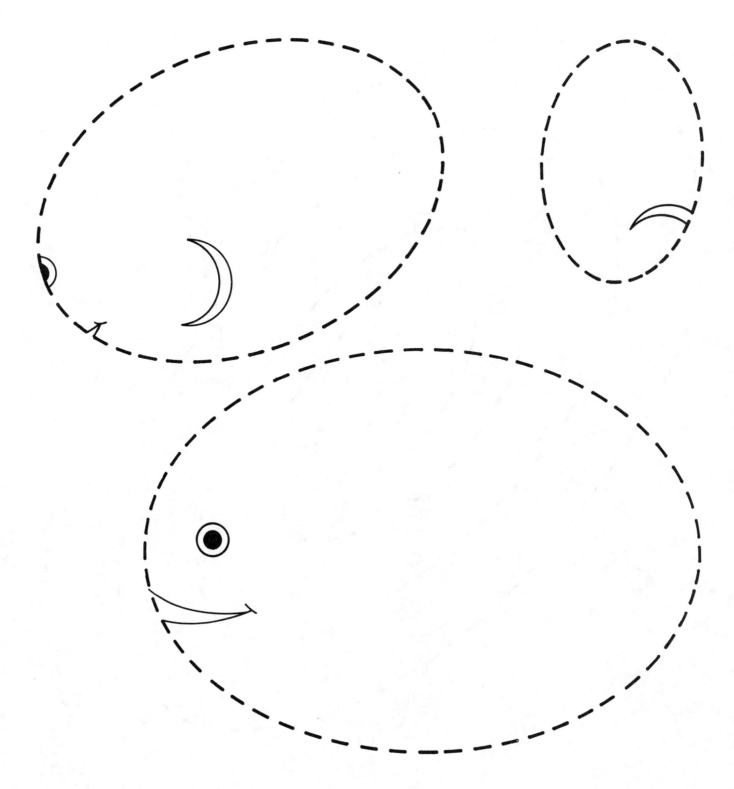

Name _____

Start at the dot. Follow the broken line with a crayon.
Color the rest of the shape. Cut along the broken line.

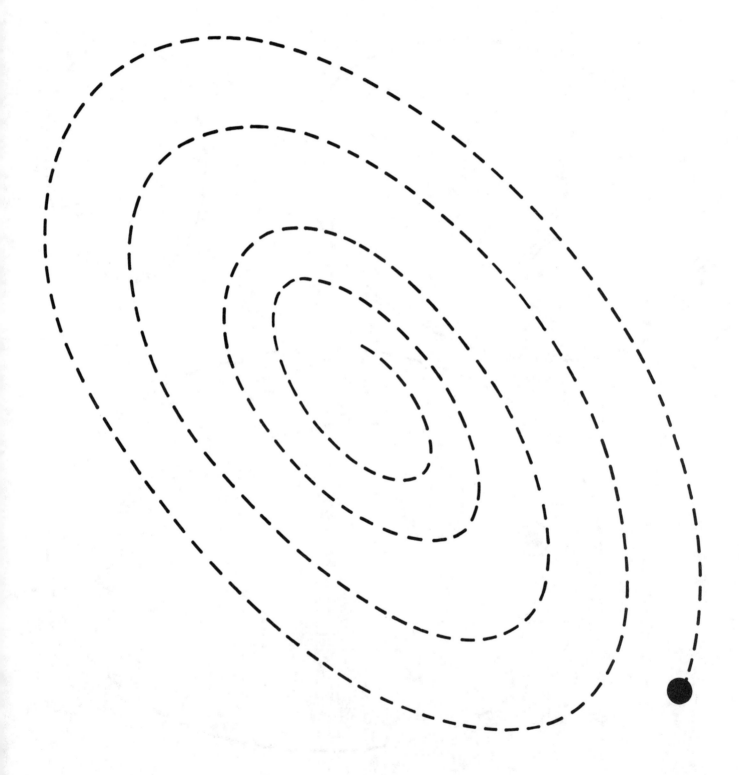

Colors and Shapes © 1988

Name _____

Color the ovals below. Then cut them out.
Glue them on another piece of paper to make this swan.

Name _____

Color the shapes. Then cut them out.
Glue them on another piece of paper to make this igloo.

Name _____

Color the shapes. The cut them out.
Glue them on another piece of paper to make this sun.

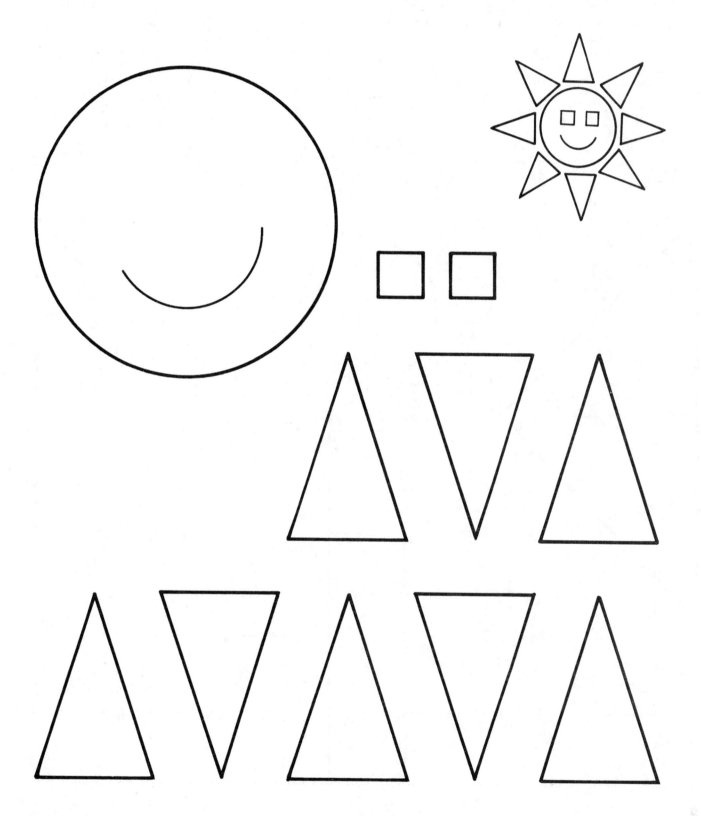

Name _____

Color the shapes. Then cut them out.
Glue them on another piece of paper to make this butterfly.

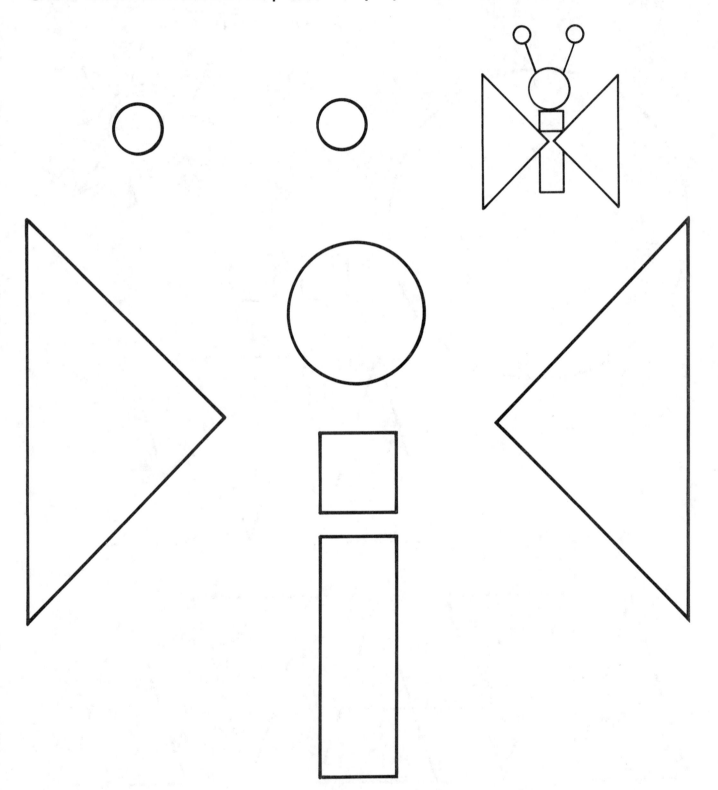

Name _____

Color the shapes. Then cut them out.
Glue them on another piece of paper to make this racer.

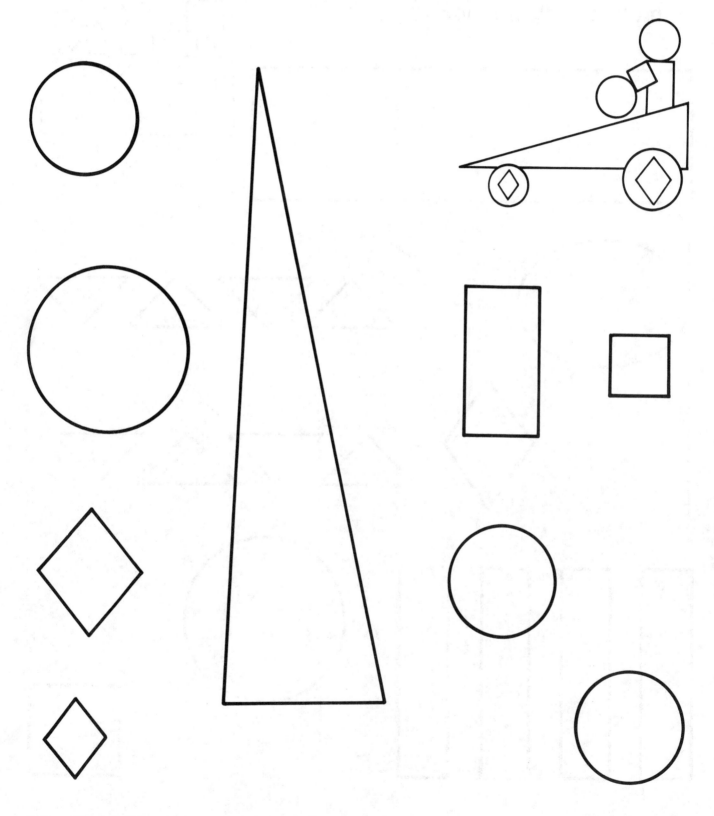

Name _____

Color the shapes. Then cut them out.
Glue them on another piece of paper
to make this flower box.